# KISMET

Tamara Albanna

leaf
publishing
house

How do you mend a breaking heart?
Just before it falls to the floor and shatters into pieces
Simply decide you're no longer going to live for tragedy.
Instead, live for possibility
Wonder
Joy
The green grass
And Monarch butterflies that cross your path

*- here's to hope, may it always spring eternal*

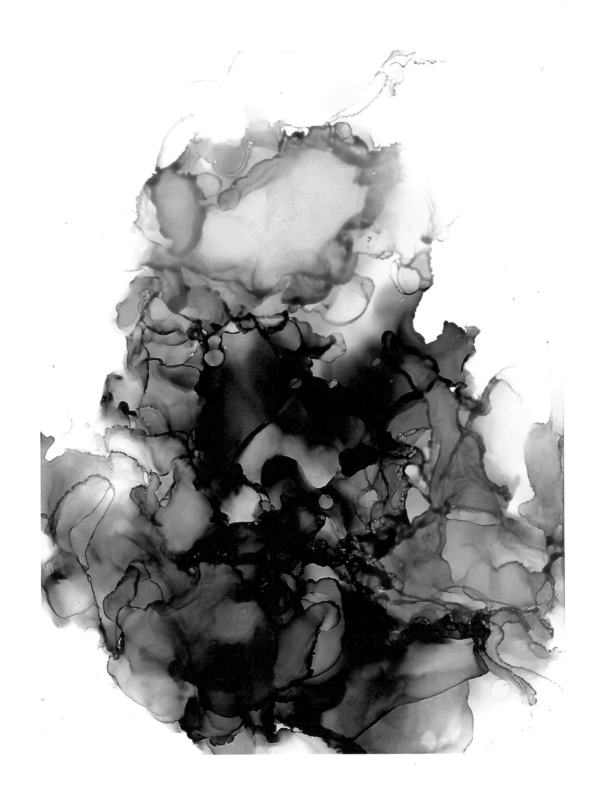

You

And

I

Like the Magdalene and Christ

Eternal flames of love consume us both

Ties that bind

Lifetime after lifetime

Through the wilderness

And dark blue seas

I will find you

And you will find me

*- red threads*

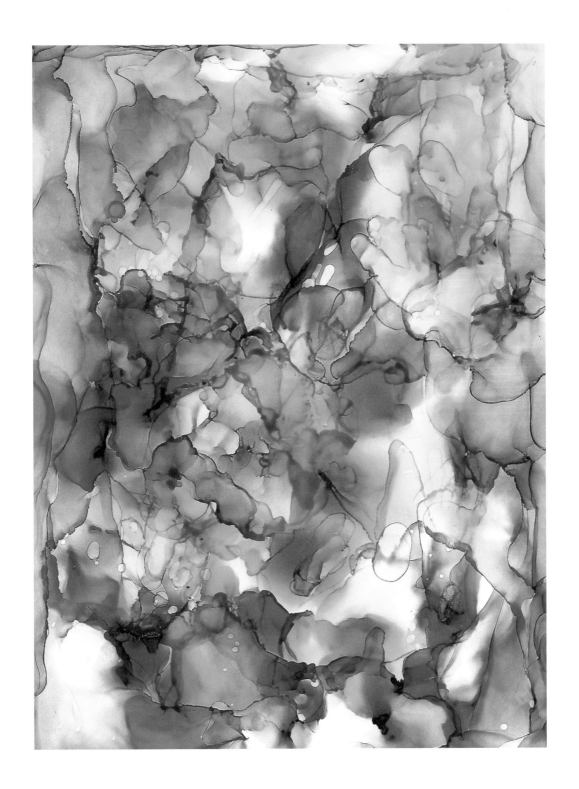

Through the clouds
In the plane without you
Did your heart hear mine
Did my message get through?

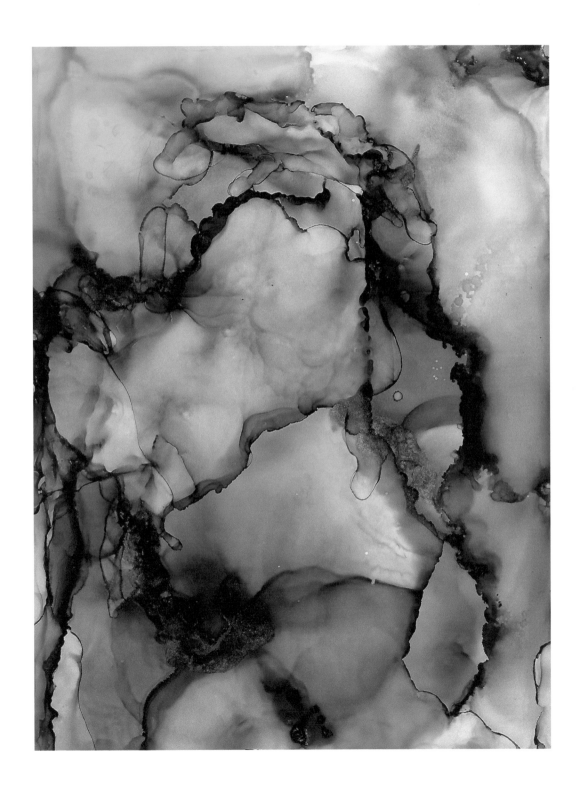

They say time is an illusion
But its cruelty is real
Palpable
Felt so deeply
It crawls and crawls when I wait to see you
And rushes to tear me away when I'm in your arms

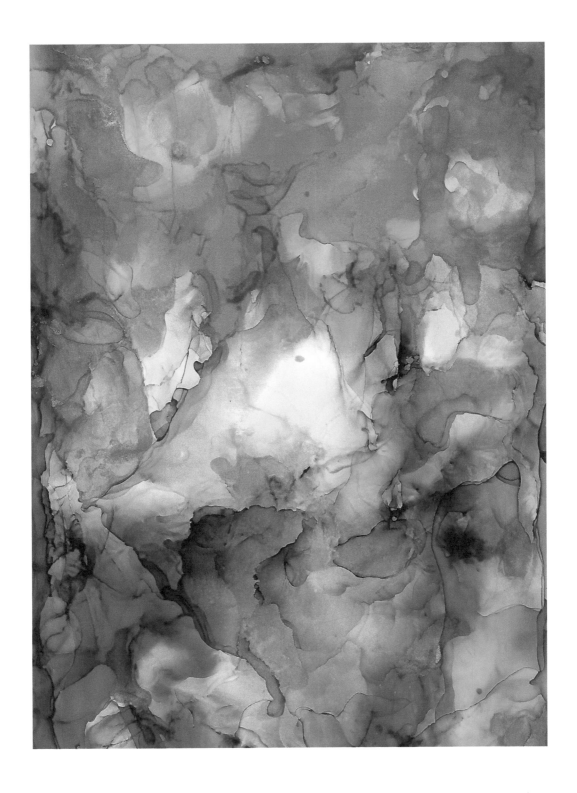

How is it that we are breathing the same air in this city
And I am
Here
You are
There
Shall I open up this window and tell the birds to give you a message for me?

"Tell him I love him, please"

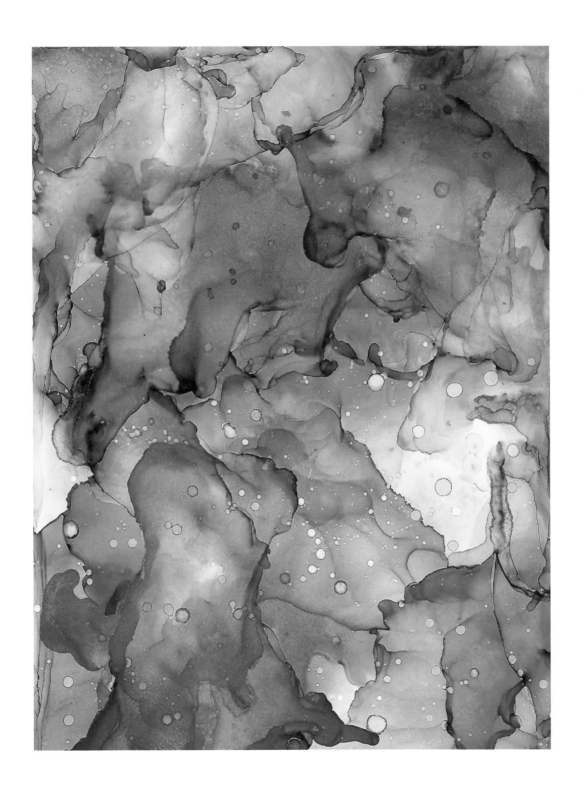

The raindrops hit the the window
At the same time as the tears rolled down my face
The door had barely closed behind you
But suddenly the sun
Tried to peek out from the oppressive clouds
And you returned for one last
Embrace
One last kiss
Until we meet again

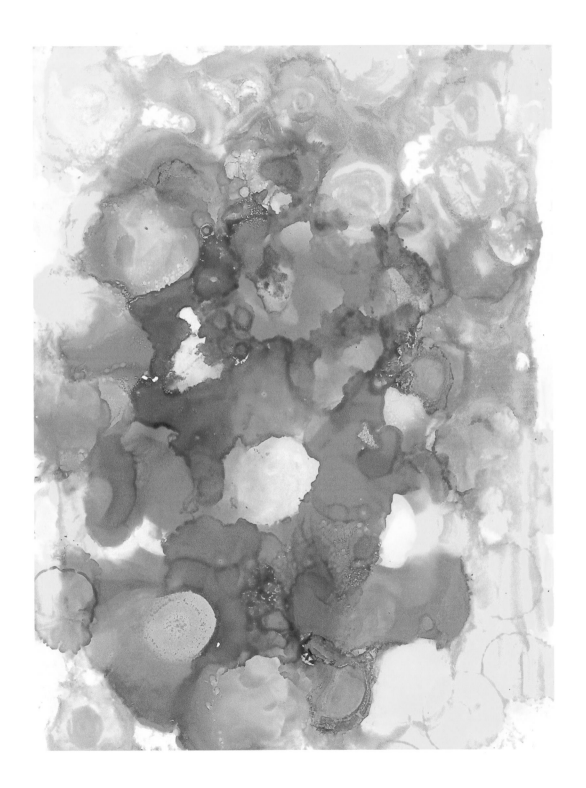

But my love
I just don't want to cry anymore
The well has run dry
There's no way to drown
The ink keeps running down these pages
And I'm forgetting my words

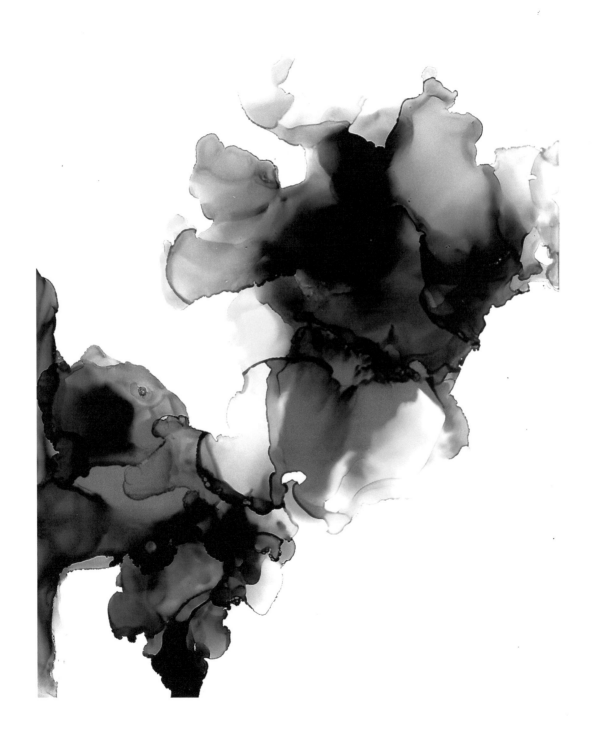

The Sun lives in your skin
So open and warm
Rich deep caramel like sweetness
While the moon resides in mine
Often times withdrawn and cold
With a hint of bitterness from the unwanted touch
that was endured for so long before
You
But when our worlds collide
It is more wondrous than an eclipse
One doesn't overshadow the other
We merge
In love and beauty
Light and darkness
Mystery and wonder
All at once

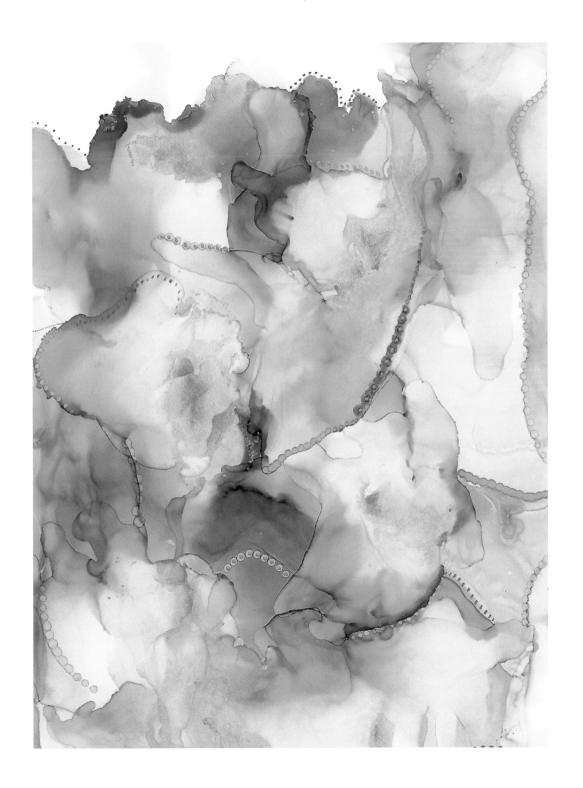

We would always joke and say
To infinity and beyond
To the moon and back
Always, and forever
Look at us

The stars have aligned
And the planets too

It's you and me

My soul and yours

*- intertwined*

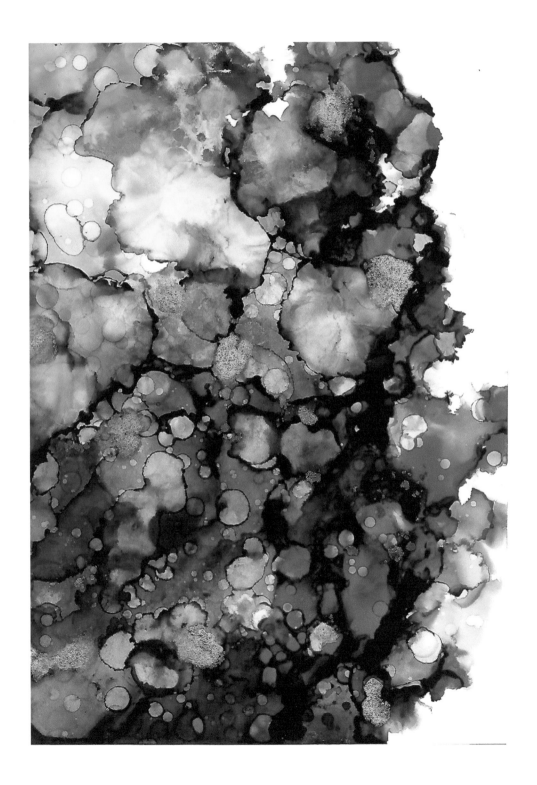

You saved my life
And it's not because I would die without you
Its because with you
I feel life
Not just living
I am alight

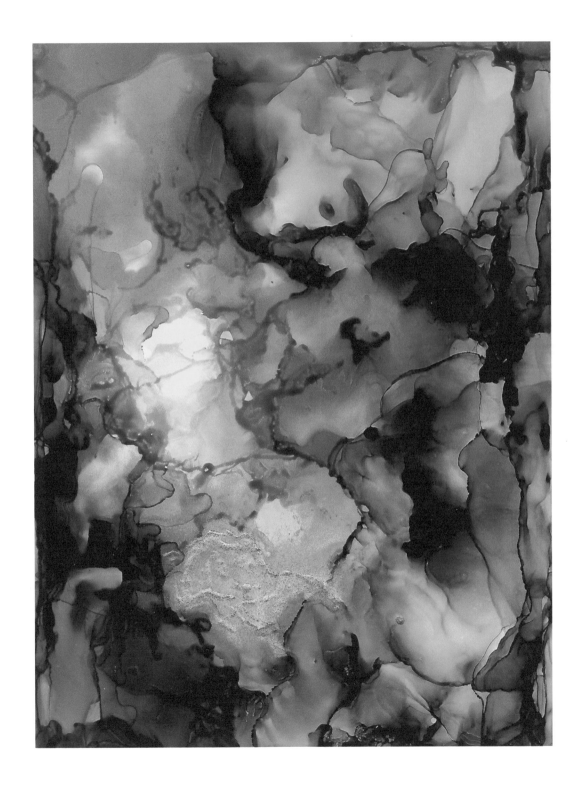

Promise me you will ask for me in heaven too
I love you too much, one lifetime simply isn't enough

- *Jannah*

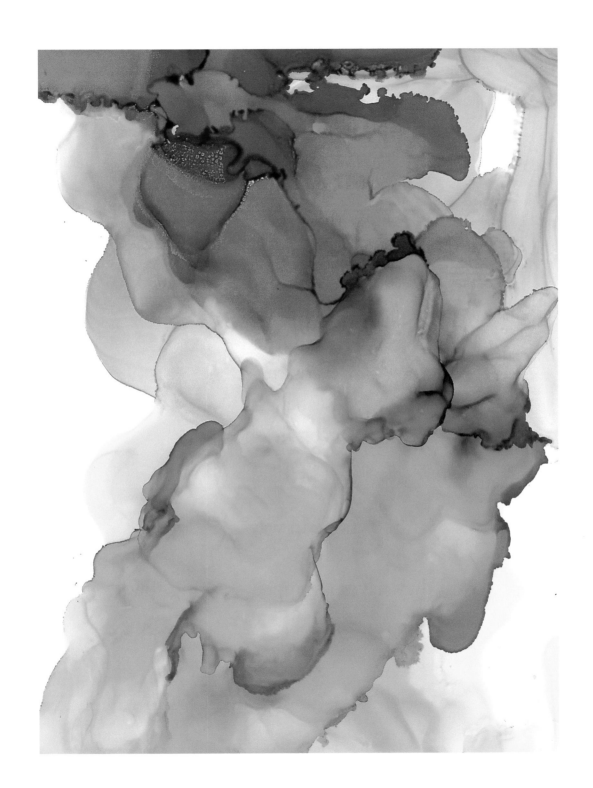

It was magnetic
Like it happens in the movies
Only this was real life
Time stood completely still
All others disappeared around us
When my eyes met yours
They burned
I felt the tears
Disbelief
Recognition
And gratitude

Came in waves

And they haven't stopped crashing since

*- first sight*

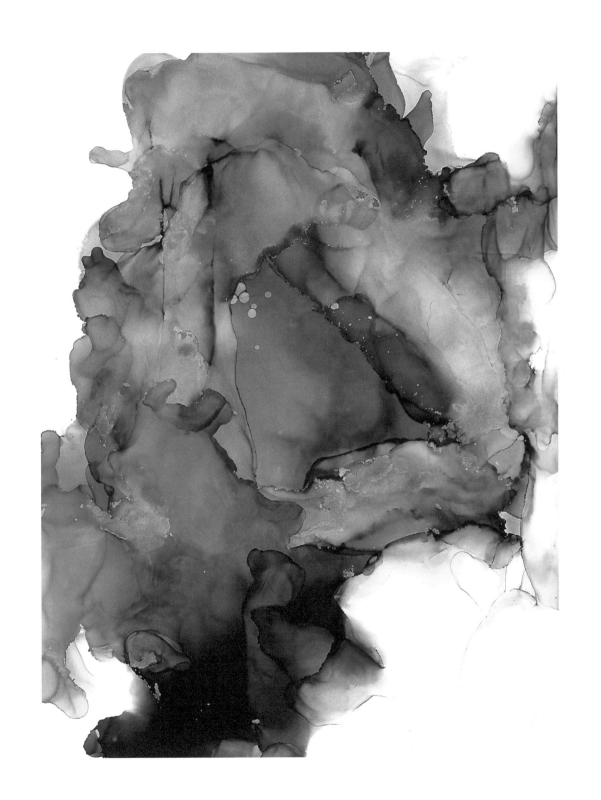

If I could tear my heart out
As it still beats
And hand it to you
It still wouldn't be enough to say
How much I love you

*- let my heart speak*

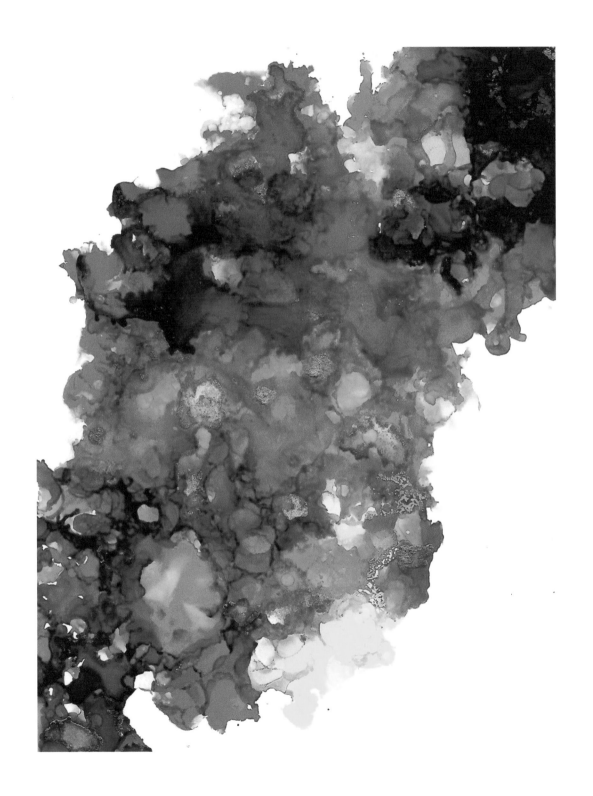

I would gladly die a thousand deaths
And in every incarnation
My soul would seek yours

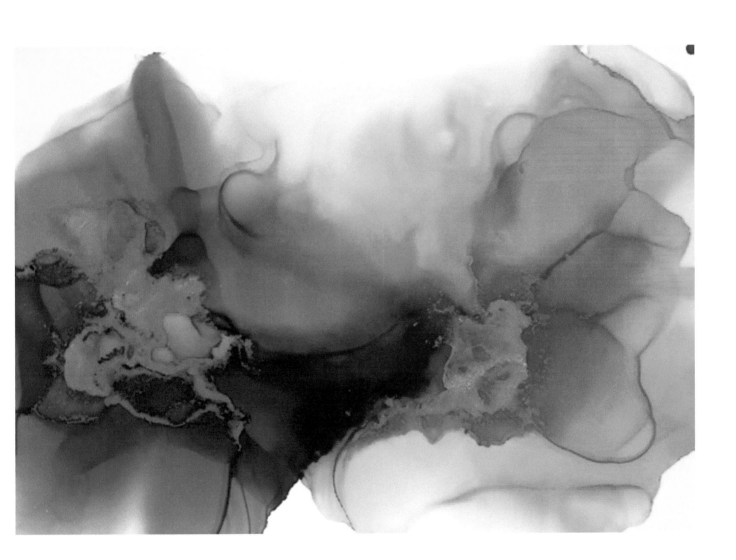

My light
My love
My boundless joy
Like the sun on my face
And a cool breeze
This is what you are to me

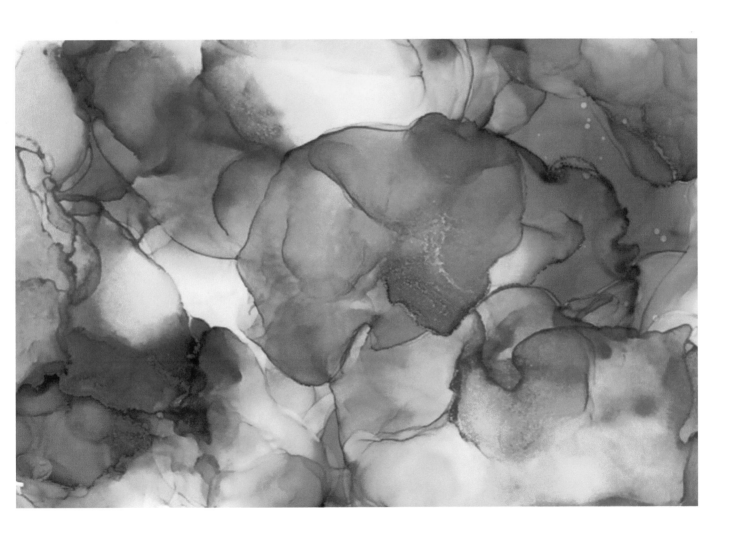

Because I was like the Moon
Only rising in darkness
You are the
Sun
You came along to shine your love so brightly
Blinding me
Reminding me
What it means to be alive

*- eclipse*

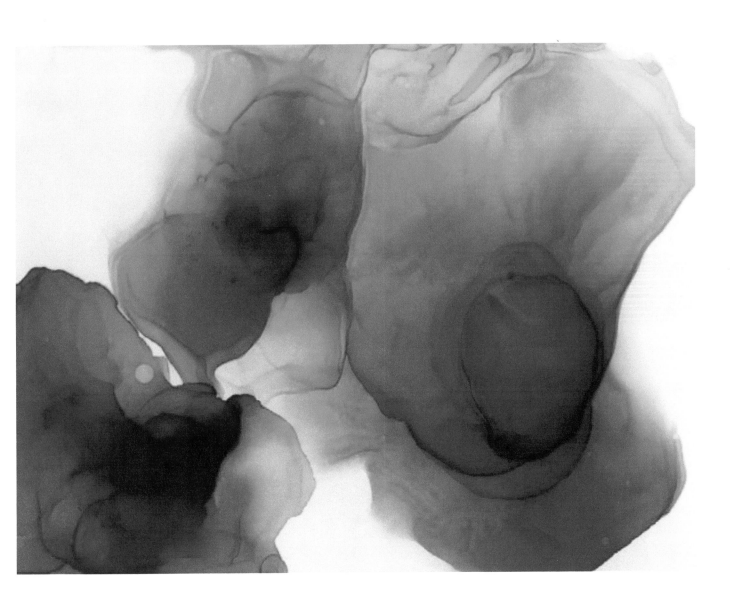

Sometimes I feel as though my heart and soul
Are already there with you
Pieces of me departed eagerly
Before I have even landed
And they wait patiently for my lifeless form to arrive
And make me whole again

*- arrival*

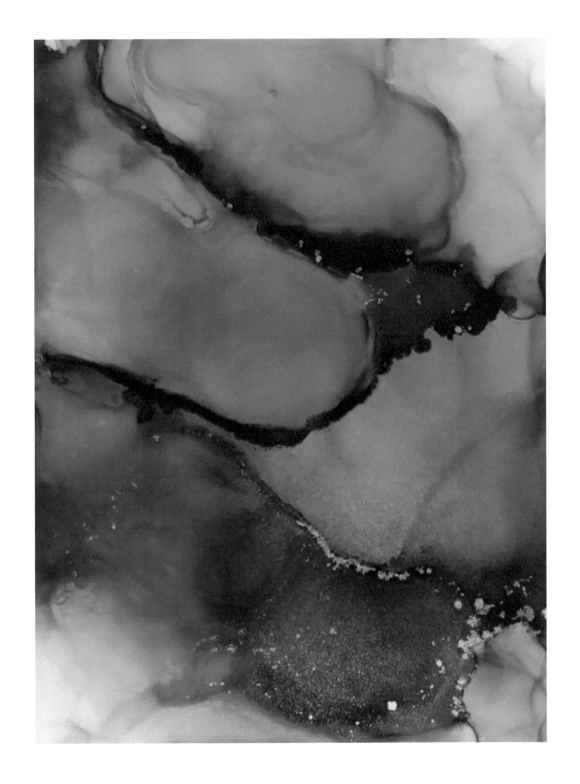

I always try and get as close to the clouds as I can
It's like I'm touching heaven
Floating
Weightless
And utter bliss

Even though miles apart

That's when I feel closest to you

*- window seat*

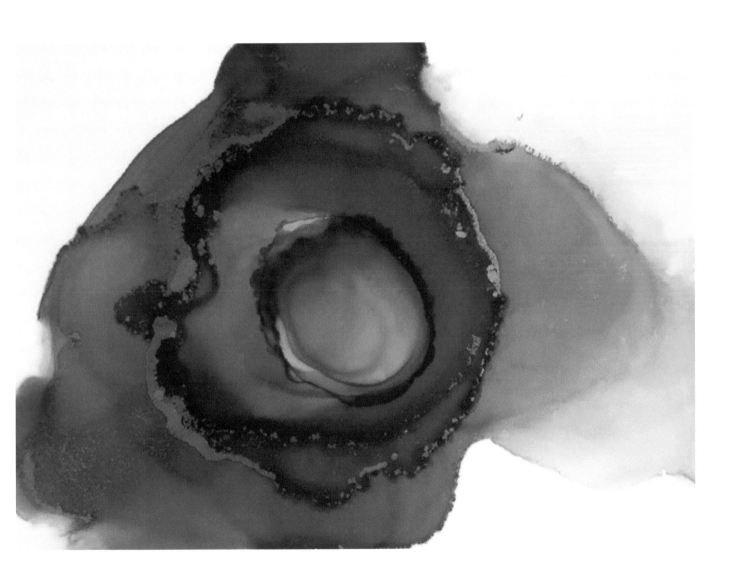

I hate this distance between us
Even when I am wrapped up in you
Safe and warm
Under the light of the moon
I cannot help but think of tomorrow
The next day
All the time without you

*- departure*

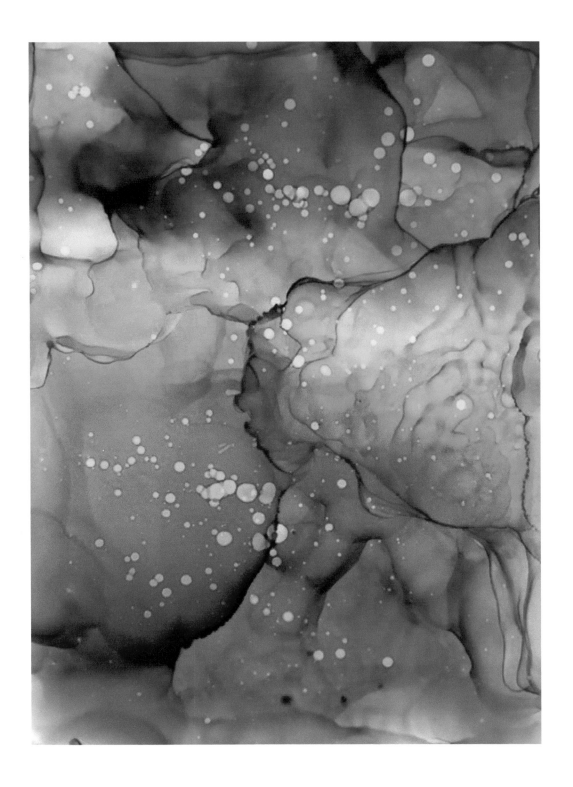

I often wake at night and turn to look for you
To nuzzle my face in the warmth of your neck
The intoxicating musk of your scent
The way you wrap your legs around mine
I would joke, in my mind
"I'm not running away"
I couldn't if I wanted to
My heart wouldn't allow me
Light kisses on my face
I feel them in my sleep
I turn to look for you
But you aren't there

My love,

Won't you come find me?

*- I woke up in the wrong bed*

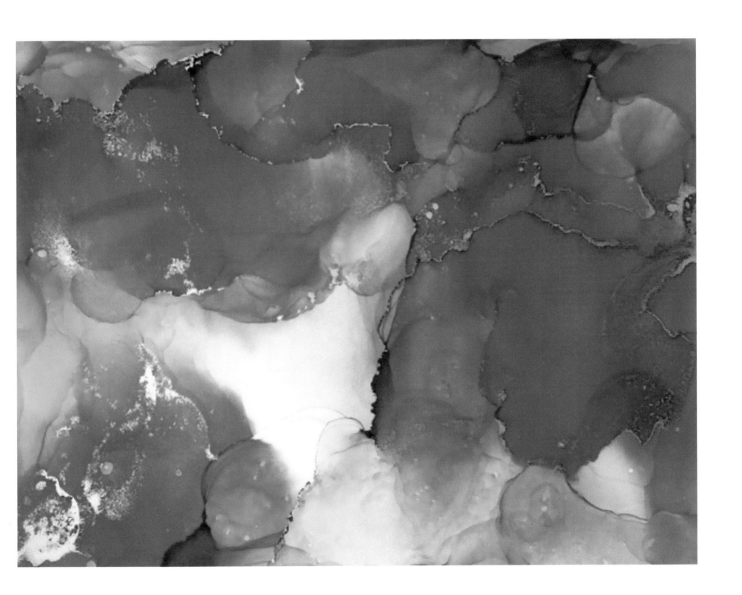

Completely unexpected
And yet, so long overdue
I never thought you'd arrive
I figured it was too good to be true

Like a beautiful natural disaster, you came
And I was swept up in you

A word to the wise
Be careful what you wish for

*- your love is an answered prayer*

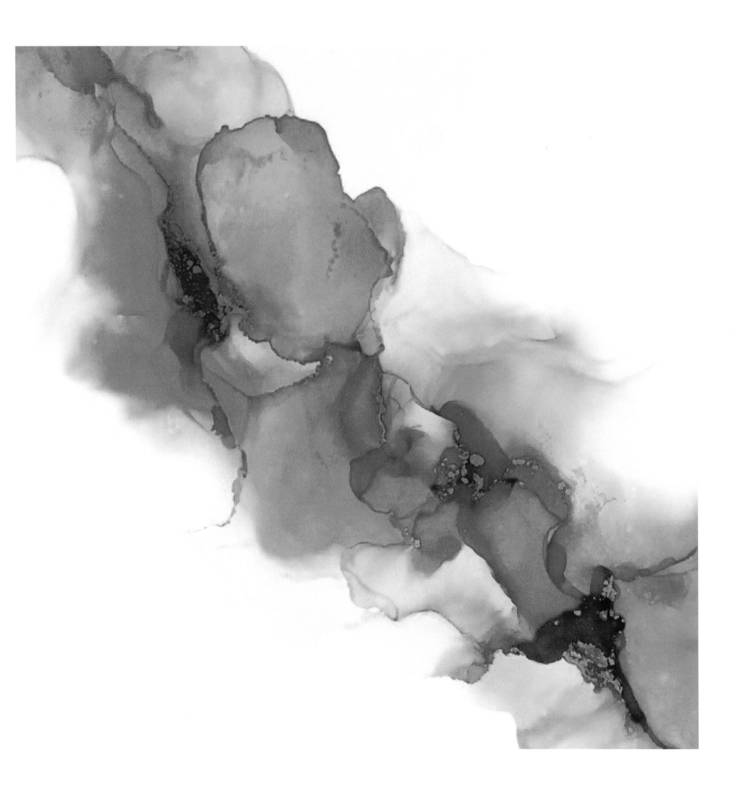

You melt into me
And I into you
Unaware of time
Or space
Slowly
Sensually
We move

*- like honey*

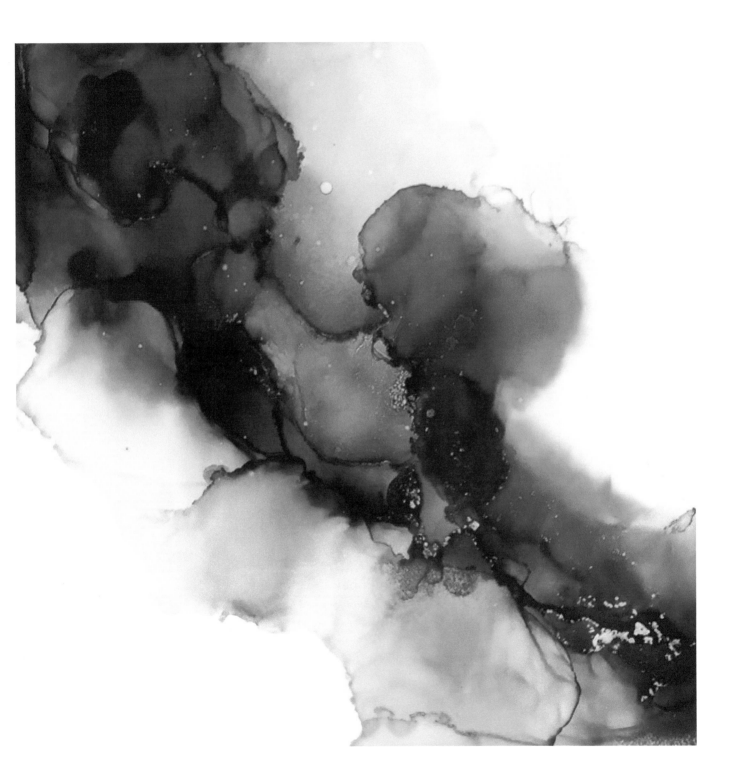

I asked you to say it
If even in a whisper
You and I
In a close embrace
A union blessed by the Divine
To watch the words, spill from your lips
The same lips that kissed me every chance they could get
I just wanted to be able to say

"Yes"

- *nikkah*

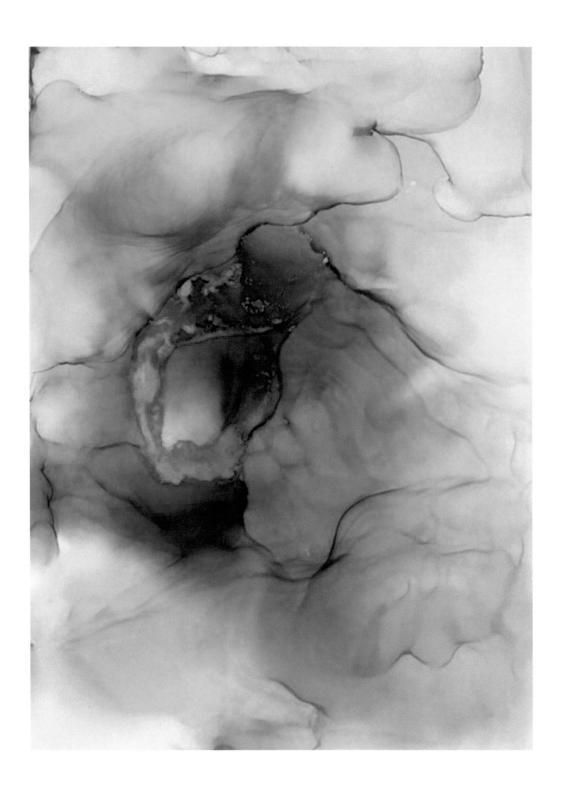

That time I awoke
To find you looking at me
The first words out of your mouth were the
Ones I was longing to hear
For years
Lifetimes even
It was worth the wait

*- you are so beautiful*

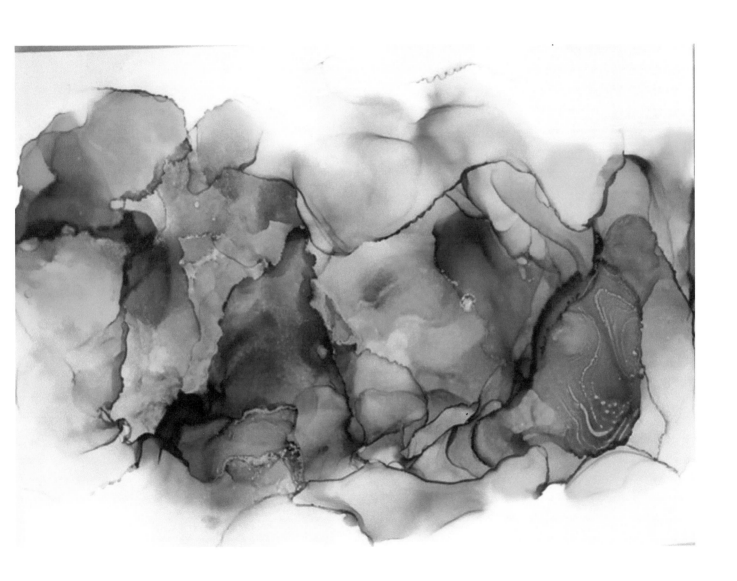

I loved you
Because I saw the Motherland within you
Even after all these years
Of aimless wandering
No home
No country
Within you, I saw Her again
Suddenly I was home
You were my country
When you held me
She held me like I never left
Like I was never torn from Her lap
And Her sweet embrace
She told me that She sent you
That you knew of my homesickness
And that I could stop wandering now

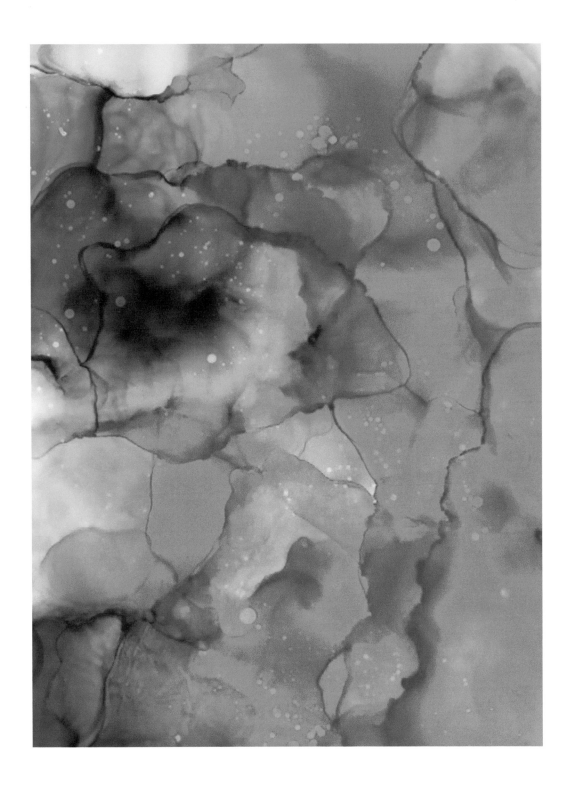

Dumuzi
My Dumuzi
Without the betrayal

My soul has wandered aimlessly
Lifetime
After
Lifetime
Searching for you

I have descended to such depths
And seen unimaginable darkness
Without you

I would walk through it all
Again and again
Through the fire my darling
If only you would be there upon my ascent

Soon my love
I will be able to name you
And all will know why
I bloom once again

That time when the heavens opened up
And the rain came pouring down, almost violently
It soaked us both but we laughed while
Others rushed for cover around us
Like a baptism that took away all sorrow
All fears about tomorrow
All worries about separation
Washed away in the flood of a force
Beyond us all

*- Kismet*

Wild woman
Is how I felt
When you looked at me and said,

"Your hair"

The rain had transformed me
Soaked my straightened hair
Into a curly wild-ness
My natural state
Of primal feminine
Not the proper and prim
The unruly wild woman
Within
Waiting for the force of nature
To show me who I really am

Never in a thousand years
Could I have ever imagined
My ancestors would
Prepare me for a love
As lush is this

You are the vast ocean
That my mermaid soul longs for
Every moment
When I come home to you
Your sweet waters embrace me
Like I never left

It is always that wretched space
In between
Of not knowing
When I will see you next
And what to do in the meantime
Because life is just that much more
Tedious
Monotonous
Without you

CPSIA information can be obtained
at www.ICGtesting.com
Printed in the USA
BVHW021541111220
595272BV00003B/50